Gothic and Old English ALPHABETS

Gothic and Old English
ALPHABETS
100 Complete Fonts

Selected and Arranged by

Dan X. Solo

from the

Solotype Typographers Catalog

Dover Publications, Inc. • New York

Gothic and Old English Alphabets: 100 Complete Fonts is a new work, first published by Dover Publications, Inc., in 1984.

DOVER *Pictorial Archive* SERIES

This book belongs to the Dover Pictorial Archive Series. You may use the letters in these alphabets for graphics and crafts applications, free and without special permission, provided that you include no more than six words composed from them in the same publication or project. (For any more extensive use, write directly to Solotype Typographers, 298 Crestmont Drive, Oakland, California 94619, who have the facilities to typeset extensively in varying sizes and according to specifications.)

However, republication or reproduction of any letters by any other graphic service whether it be in a book or in any other design resource is strictly prohibited.

Manufactured in the United States of America
Dover Publications, Inc., 31 East 2nd Street, Mineola, N.Y. 11501

Library of Congress Cataloging-in-Publication Data

Main entry under title:

Gothic and Old English alphabets.

(Dover pictorial archive series)
1. Printing—Specimens. 2. Type and type-founding—Gothic type. 3. Type and type-founding—Old English type. 4. Alphabets. I. Solo, Dan X. II. Solotype Typographers. III. Series.
Z250.5.G6G67 1984 686.2'24 84-5935
ISBN 0-486-24695-7 (pbk.)

Abbey English

ABCDEFGHIJKLMN
OPQRSTUVWXYZ

(&:.;-"!?$¢£)

abcdefgghijklmno
pqrstuvwxyz

1234567890

Academy Text

ABCDEFGHI
JKLMNOPQR
STUVWXYZ

abcdefghijklmnop
qrstuvwxyzz

1234567890

Alte Schwabacher

ABCDEFGHI
JKLMNOPQR
STUVWXYZ

abcdefghijklmnop
qrsstuvwxyz

1234567890

American Text

ABCDEFGHIJK
LMNOPQRST
UVWXYZ

abcdefghijklmnop
qrstuvwxyz

1234567890
[&.,.:;-'"!?$]

4

AMERIAN UNCIAL

ABCDEFG

HIJKLMN

OPQRST

UVWXYZ

Antique Black

ABCDEFGHI
JKLMNOPQR
STUVWXYZ

abcdefghijklmn
opqrstuvwxyz

?;:$£-'!
1234567890

Becker

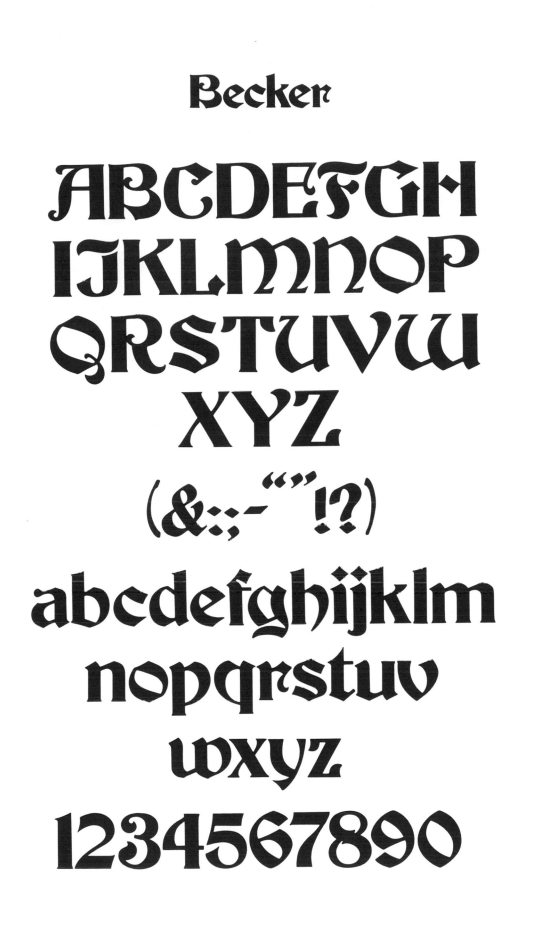

ABCDEFGH
IJKLMNOP
QRSTUVW
XYZ
(&:;-""!?)
abcdefghijklm
nopqrstuv
wxyz
1234567890

Behrens-Schrift

ABCDEFGHI
JKLMNOPQR
STUDWXYZCh
abcdefghijklm
nopqrſstuvwx
12345·yz·67890

Bella Initials

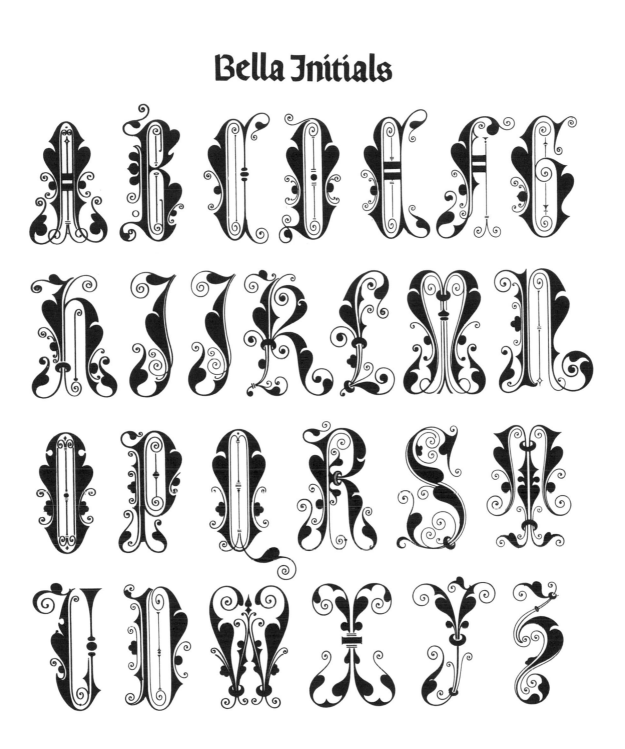

Black Ornamented

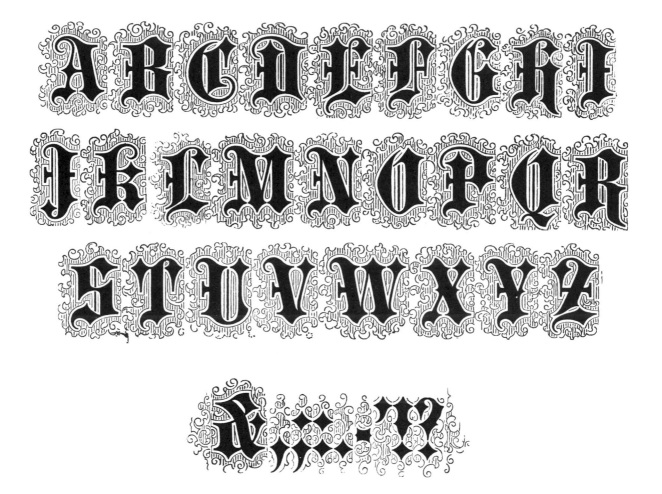

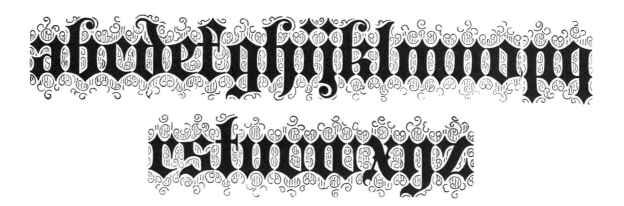

10

BLACKSTONE

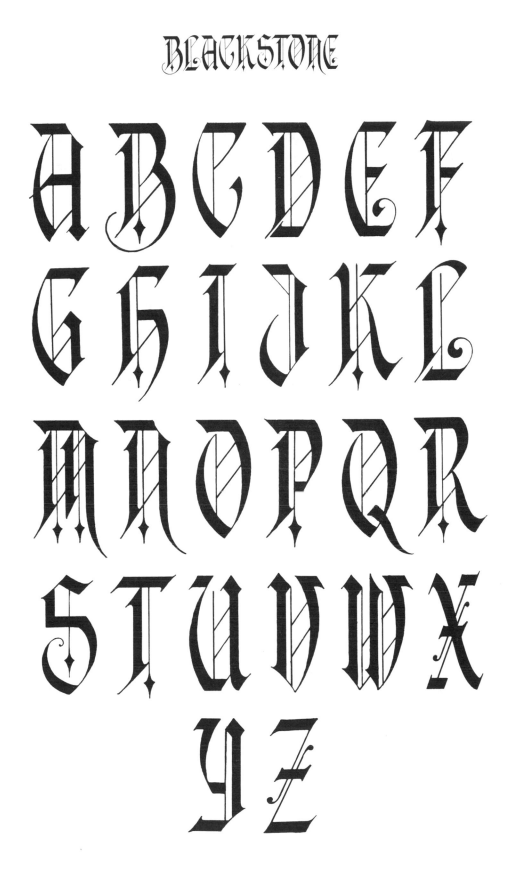

Bradley

ABCDEFGHIJK
LMNOPQRST
UVWXYZ

abcdefghijklmno
pqrstuvwxyz

1234567890
(&.,.:;-''!?$¢)

Bradley Initials

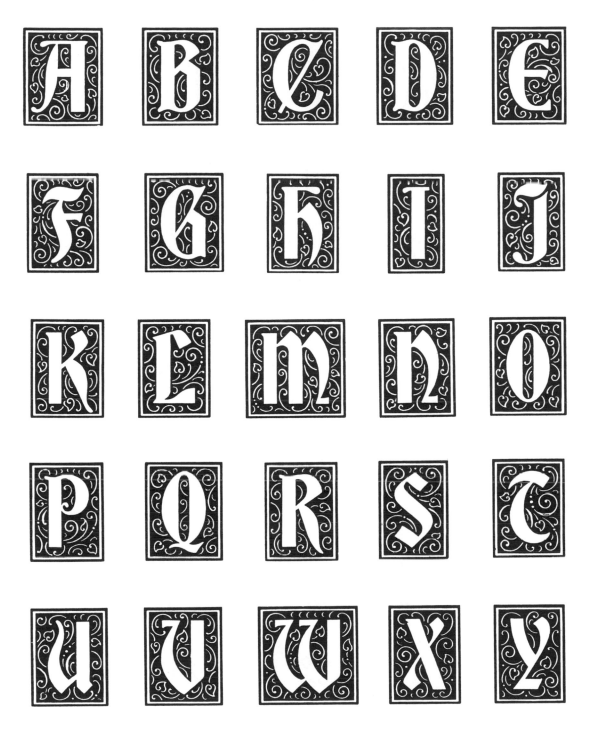

Bradley Outline

ABCDEFGHIJK
LMNOPQRST
UVWXYZ

abcdefghijklmno
pqrstuvwxyz

1234567890
(&.,:;''!?$¢)

CALIGRAPH

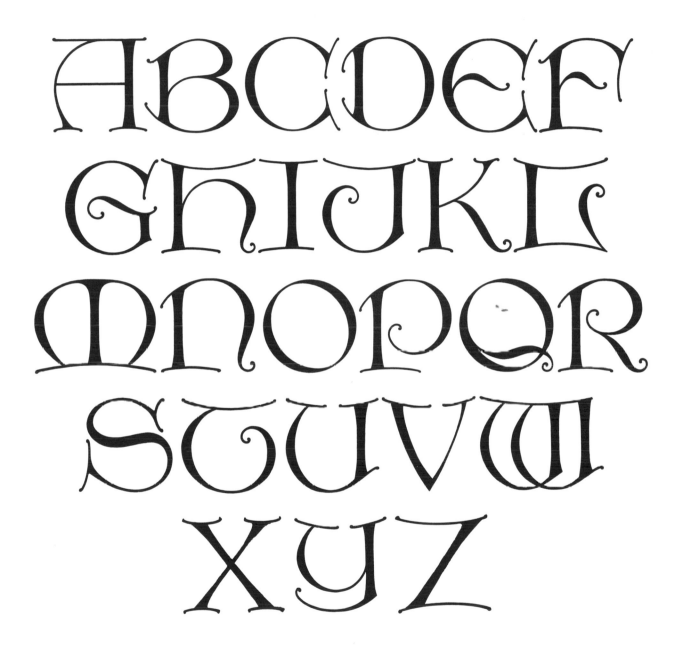

ABCDEF
GHIJKL
MNOPQR
STUVW
XYZ

Castlemar

ABCDEFGHI
JKLMNOPQRS
TUVWXYZ

abcdefghijklmno
pqrstuvwxyz

1234567890

CAXTON

INITIALS

ABCDEFG HIJKLMN OPQRSTU VWXYZ ✠

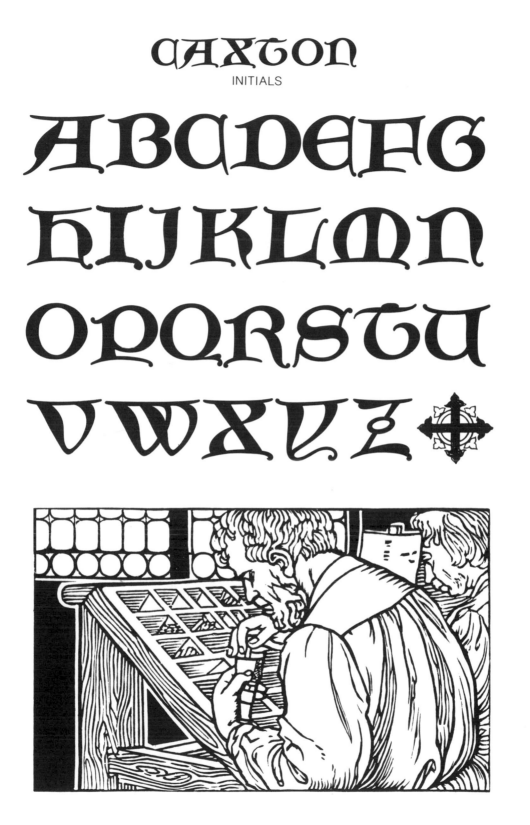

Celebration Text

ABCDEFGHI
JKLMNOPQR
STUVWXYZ

abcdefghijk
lmnopqrstuvwxyz
$£1234567890¢
&.,:;-'""!?

Chalet Text

ABCDEFGH
IJKLM
NOPQRSTU
VWXYZ

abcdefghijklmn
opqrstuvwxyz

1234567890
&.,:;""''!

Chaucer Text

ABCDEFGHI
JKLMNOPQR
STUVWXYZ

abcdefghijklmnopqrst
uvwxyz

1234567890

Church Text

ABCDEFGH
IJKLMNOP
QRSTUVW
XYZ

abcdefghijklmnopqr
stuvwxyz

1234567890

Claudius

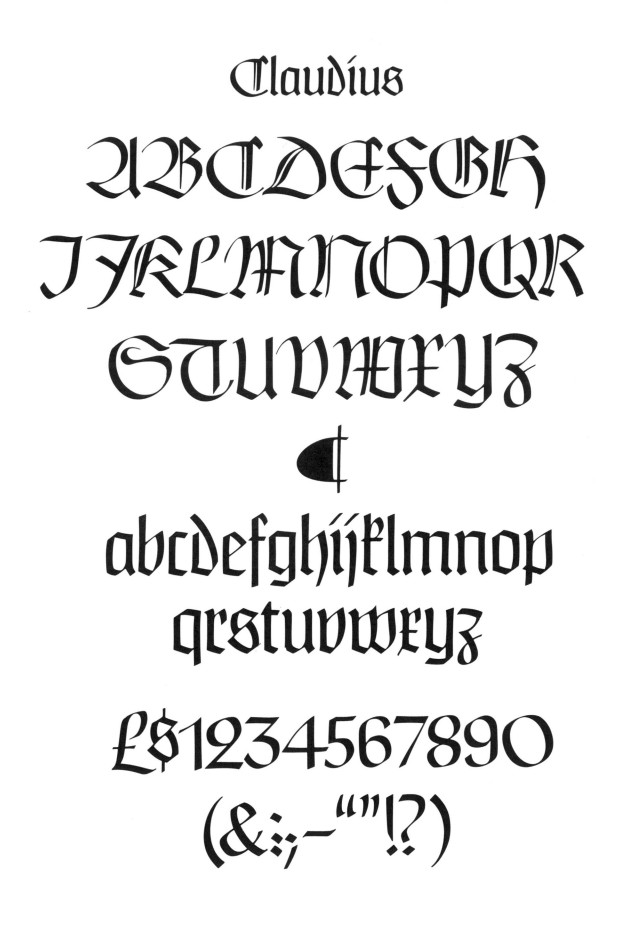

ABCDEFGH
IJKLMNOPQR
STUVWXYZ
C

abcdefghijklmnop
qrstuvwxyz

£$1234567890
(&:;–""!?)

Concordia Text

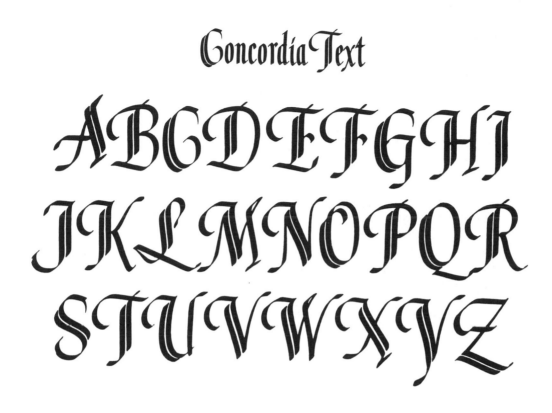

A B C D E F G H I
J K L M N O P Q R
S T U V W X Y Z

[&:; "-" $¢]

abcdefghijklmnopqrst
uvwxyz

1234567890

Continental Text

ABCDEFGHI
JKLMNOPQR
STUVWXYZ

&!?

abcdefghijklmno
pqrstuvwxyz
1234567890

DOLBEY

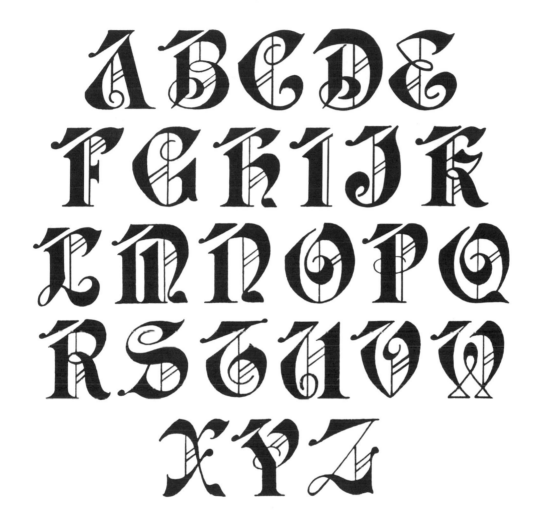

Dublin Text

ABCDEFGHIJ KLMNOPQR STUVWXYZ

abcdefghijklmn opqrstuvwxyz

1234567890

26

Ecclesiastic

A B C D E F G
H I J K L M N O
P Q R S T U V
W X Y Z

&

a b c d e f g h i j k l
m n o p q r s t u
v w x y z

$ 1 2 3 4 5 6 7 8 9 0

English Shaded

ABCDEFGH
IJKLMNOPQ
RSTUVWXYZ

abcdefghijklm
nopqrstuvwxyz

1234567890

(&:;,-"'!?$£)

28

ENGRAVERS

INITIALS 2

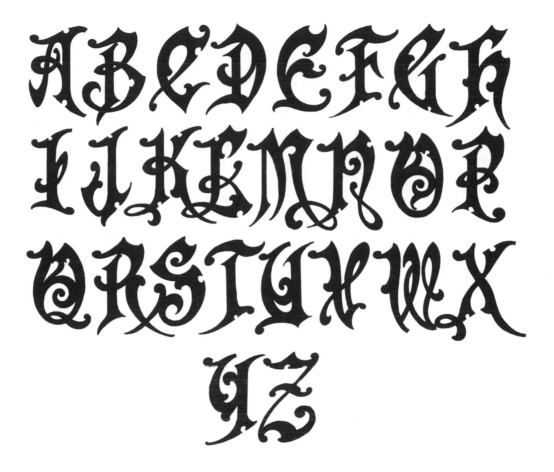

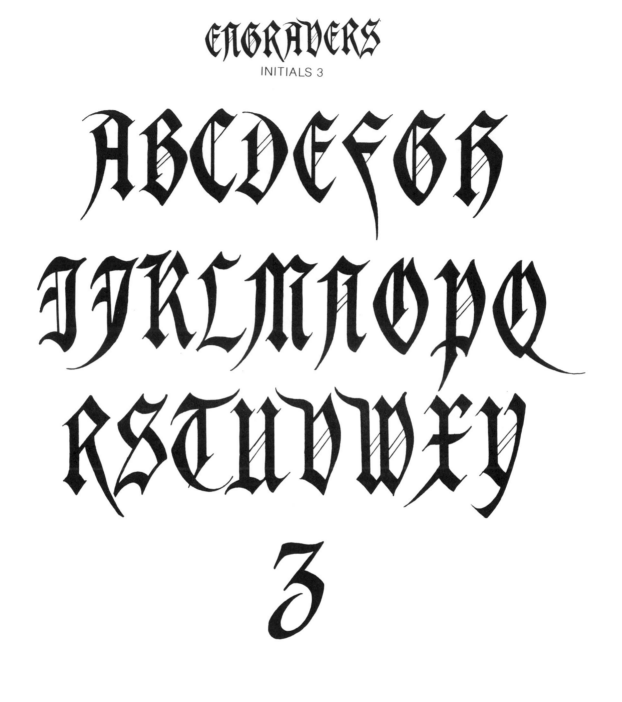

ABCDEFGH
IJKLMNOPQ
RSTUVWXY
3

Engraver's Old English

ABCDEFGH
IJKLMNOPQ
RSTUVWXYZ

abcdefghijklm
nopqrstuvwxyz

1234567890
(&.,.:;-""''!?$£¢%)

Engravers Text

A B C D E F G H
I J K L M N O P Q
R S T U V W
X Y Z

a b c d e f g h i j k l m n
o p q r s t u v w x y z

1 2 3 4 5 6 7 8 9 0

$, ; : - ' ' ? ! &

Fette Gotisch

ABCDEFGI
JKLMNOPQ
RSTUVWXYZ

abcdefghijklm
nopqrstuvwxyz

&:;-'‘'!?

1234567890

Fraktur Condensed

ABCDEFGHJ

JKLMNOPQR

STUVWXYZ

abrdefghijklmnop

qrsßstuvwxyz

1234567890

Fraktur Extra Condensed

ABCDEFGHIJKLM

NOPQRSTUVWXYZ

abcdefghijklmnopqrs

tuvwxyz ch ck ff ffi fl ft ſi ſſ ſſi ſi ſt tz

1234567890

Freehand

ABCDEFGHI
JKLMNOPQRS
TUVWXYZ&

abcdefghijklmnop
qrstuvwxyz

$1234567890¢

(.,:;!?""''-*)

Gans Bold Gothic

ABCDEFGH
IJKLMN
OPQRSTU
VWXYZ

abcdefghijklmno
pqrstuvwxyz

1234567890

Germania

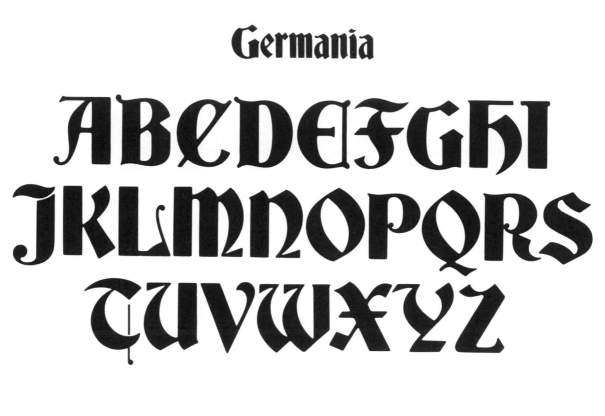

ABCDEFGHI
JKLMNOPQRS
TUVWXYZ

abcdefghijklmnop
qrstuvwxyz

1234567890

&.,:;-""!?$¢

38

Globus Bold

ABCDEFGHIJ
KLMNOPQRS
TUVWXYZ

&:.;'"!?

abcdefghijklmno
pqrstuvwxyz
1234567890

Goudy Mediaeval

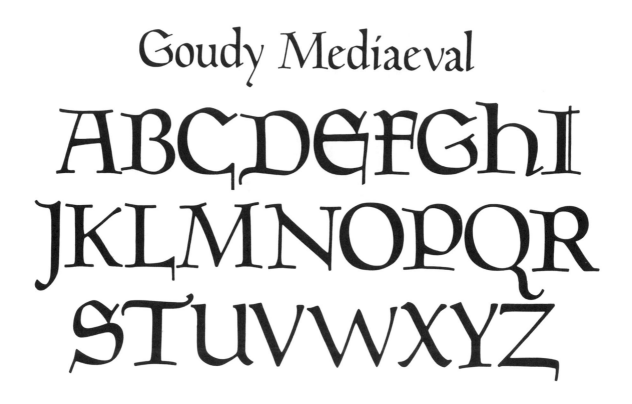

ABCDEFGHI
JKLMNOPQR
STUVWXYZ

abcdefghijklmnop
qrstuvwxyz

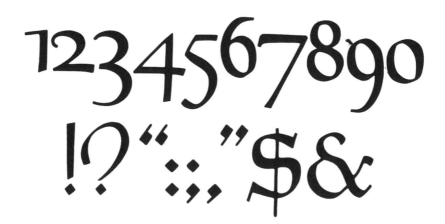

1234567890
!?":;,"$&

Goudy Text

ABCDEFGHIJ
JKLMNOPQ
RSTUVW
XYZ

abcdefghijklmnopqrs
tuvwxyz
1234567890 $&!?

Graphic Text

ABCDEFG

HIJKLMNO

PQRSTUV

WXYZ

&.,:;'"-?!

abcdefghijklmnop

qrstuvwxyz

1234567890

Holland Gothic

A B C D E F

G H I J K L M

N O P Q R S T

U V W X Y Z

1 2 3 4 5 6 7 8 9 0

(&.:;"!?)

a b c d e f g h i j k l m n

o p q r s t u v w x y z

Innsbruck

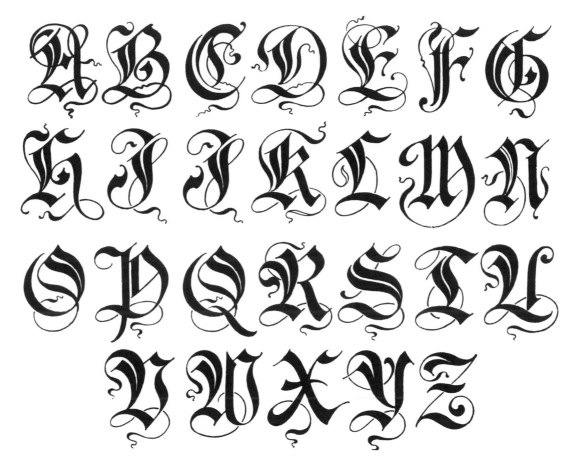

a b c d e f g h i j k l m n

o p q r s t u v w x y z

1 2 3 4 5 6 7 8 9 0

Kanzlei Bold

ABCDEFGHI
JKLMNOPQR
STUVWXYZ

abcdefghijklmnop
qrstuvwxyz

1234567890

Kanzlei Light

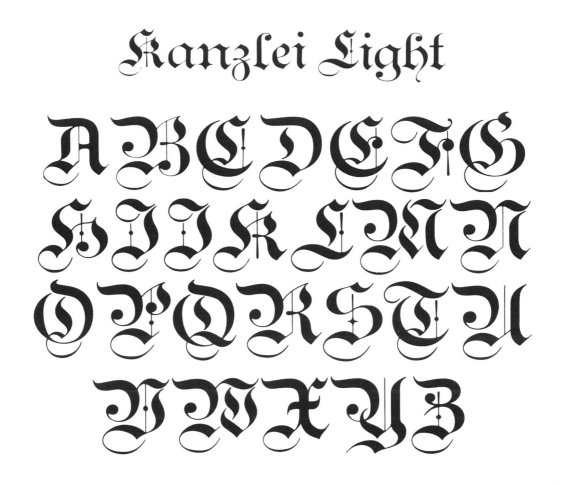

A B C D E F G
H I I K L M N
O P Q R S T U
V W X Y Z

abcdefghijklm
nopqrſstuv
wxyz

1234567890

KIMBERLEY INITIALS

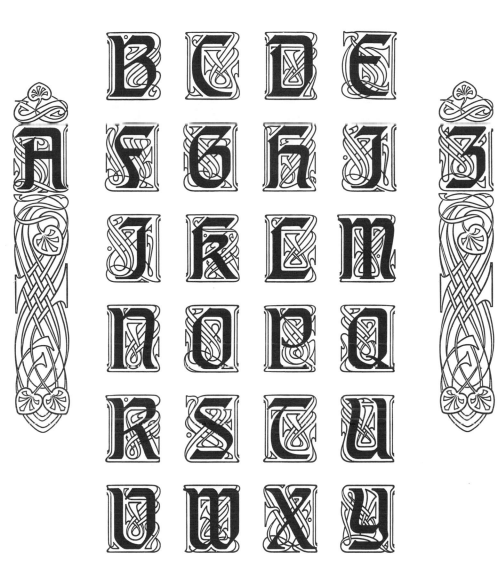

Kimberley Text

ABCDEFGHIJKLMN
OPQRSTUVWXYZ

abcdefghijklmnopqrs
tuvwxyz

1234567890

Klingspor Text

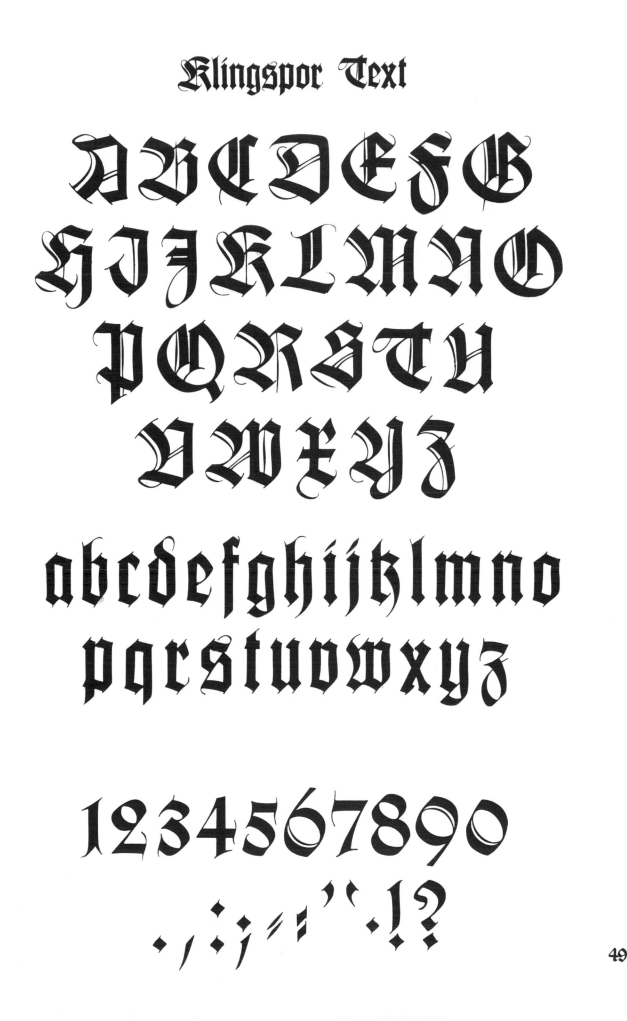

ABCDEFG
HIJKLMNO
PQRSTU
VWXYZ

abcdefghijklmno
pqrstuvwxyz

1234567890

.,;:'"!?

Lautenbach

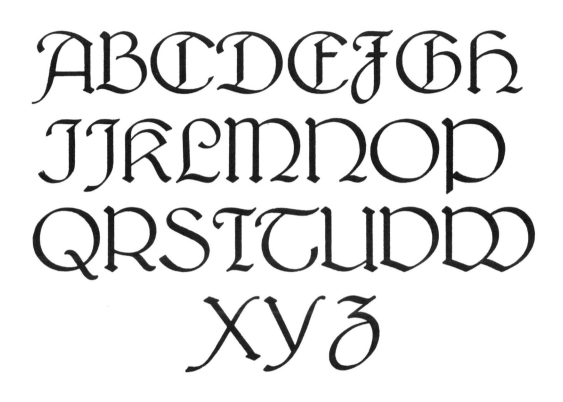

ABCDEFGH
IJKLMNOP
QRSTUVW
XYZ

abcdefghijklmnn
opqrstuvwxyz

1234567890
=&,

Lautenbach Initials

A B C D E F
G H I J K L M
N
O P Q R S T
U V W X Y Z

LIBRA

abcdefgh
ijklmnopq
rstuvw
xyz

1234567890
$.,:;'"-!?

Medieval

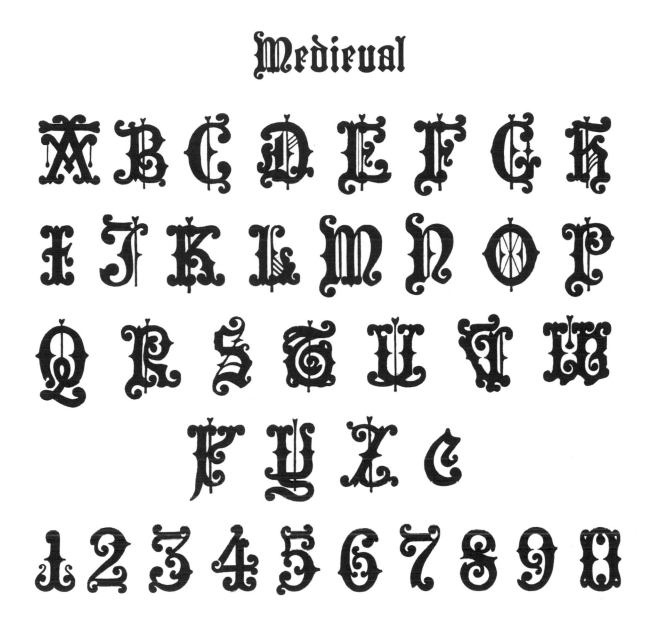

A B C D E F G K
I J K L M N O P
Q R S T U V W
X Y Z C

1 2 3 4 5 6 7 8 9 0

Memorial

A B C D E F G H I
J K L M N O P Q
R S T U V W X
Y Z & . , - ' ! ? $

a b c d e f g h i j
k l m n o p q r s t
u v w x g z 1 2 3
4 5 6 7 8 9 0

Memorial Shaded

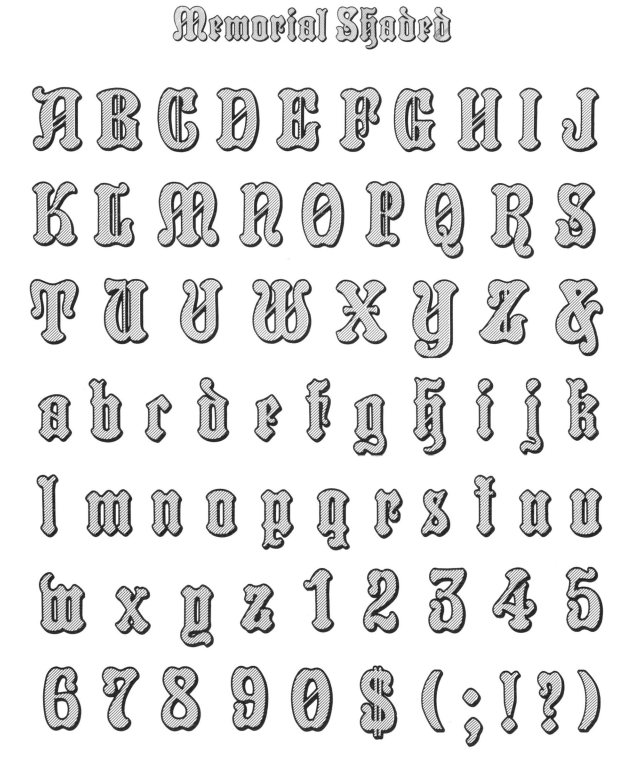

Missal Initials

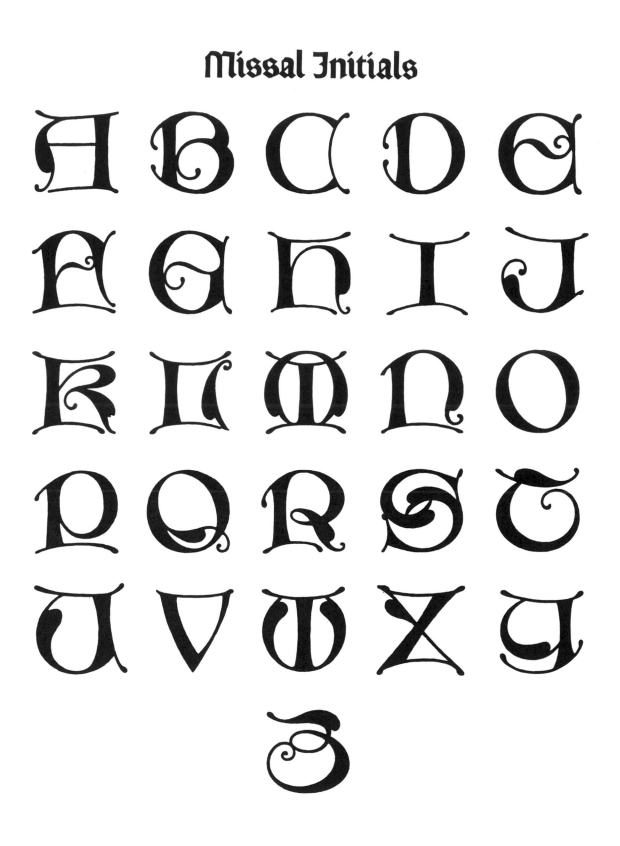

Mission No.3

ABCDEF
GHIJKLMN
OPQRSTT
UVWXYZ

abcdefg
hijklmnopqr
stuvwxyz

1234567890
(&.,:;-'!?$t/)

Monastery Text

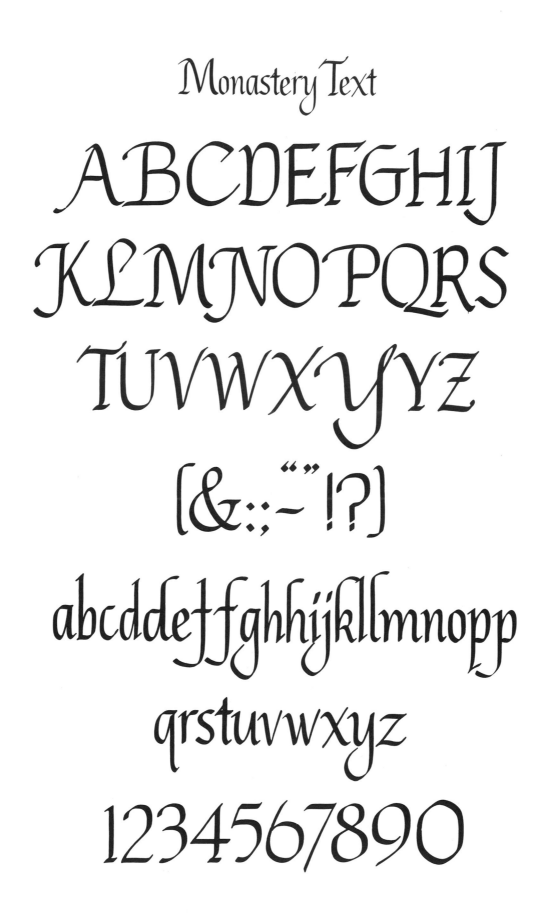

ABCDEFGHIJ
KLMNOPQRS
TUVWXYYZ
[&:;-"'!?]
abcddeffghhijkllmnopp
qrstuvwxyz
1234567890

MONMOUTH

ABCDEFGH
IJKLMNOPQ
RSTUVW
XYZ

1234567890
(&.,:;-""""!?$£¢)

Morris Black

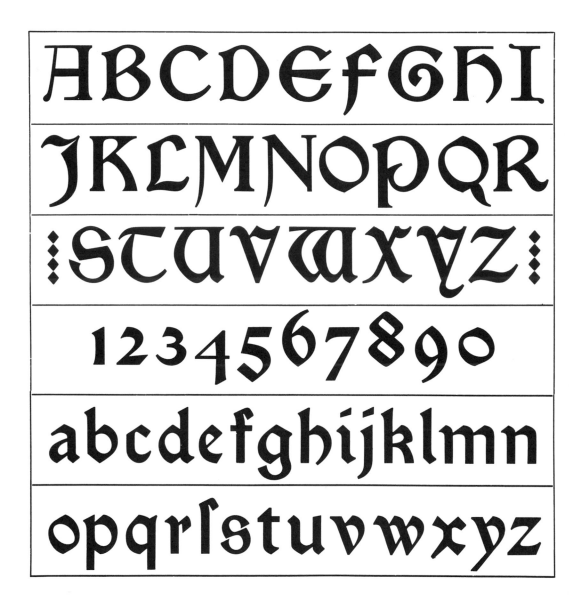

ABCDEFGHI

JKLMNOPQR

STUVWXYZ

1234567890

abcdefghijklmn

opqrstuvwxyz

MOSAIK

AAABCDEFFGGh
HIJJKLMMNOP
QRSTTUVWXYZ

1234567890
(&:;!?"-$¢)

Munich Fraktur

A B C D E F G H I

J K L M N O P R S

T U V W X Y Z

a a b c c d e f g h i j k l m

n o o p q r r ſ s t u v

ħ w x y z X

1 2 3 4 5 6 7 8 9 0

Music Hall Text

A B C D E F G H I

K L M N O P Q R

S T U V W X Y Z

abcdefghi

jklmnopqrstuvwxyz

1 2 3 4 5 6 7 8 9 0

Neptun Text

ABCDEFGH
IJKLMNOPQ
RSTUVW
XYZ

abcdefghijkl
mnopqrſs
tuvwxyz

1234567890

Nicolini Broadpen

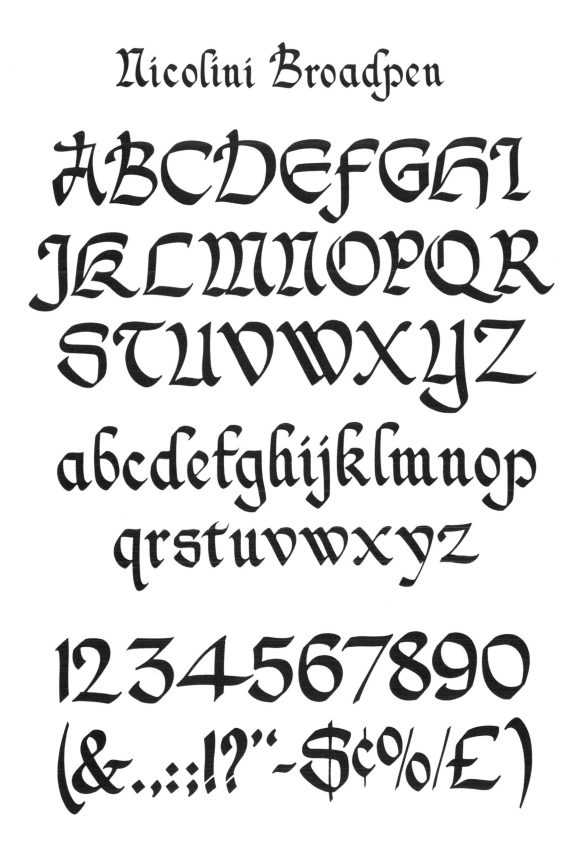

ABCDEFGHI
JKLMNOPQR
STUVWXYZ

abcdefghijklmnop
qrstuvwxyz

1234567890
(&.,.:;!?"-$¢%/£)

Old English Open

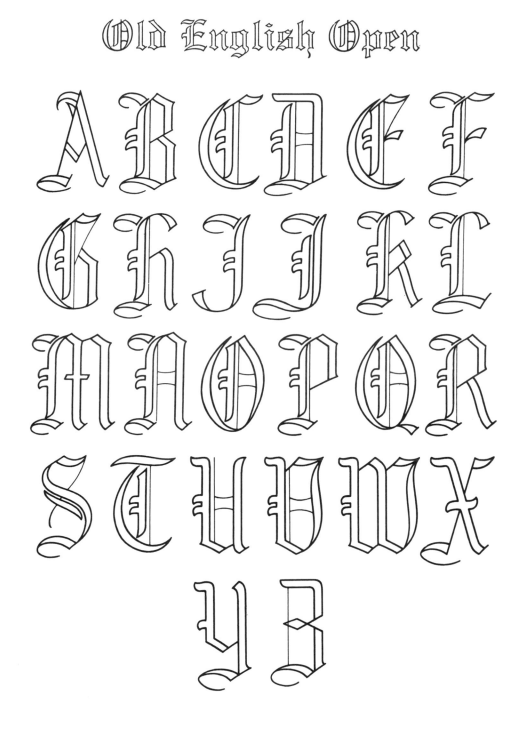

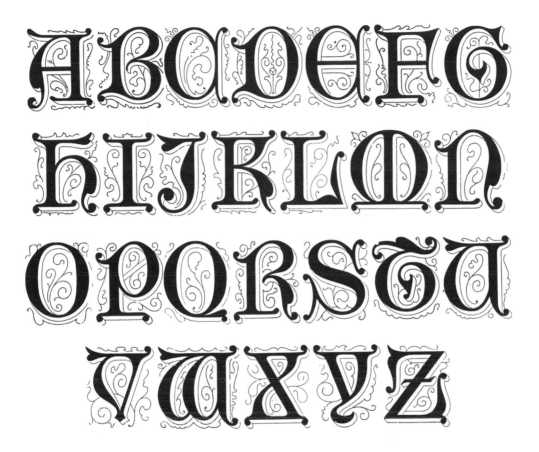

Pencraft Slope

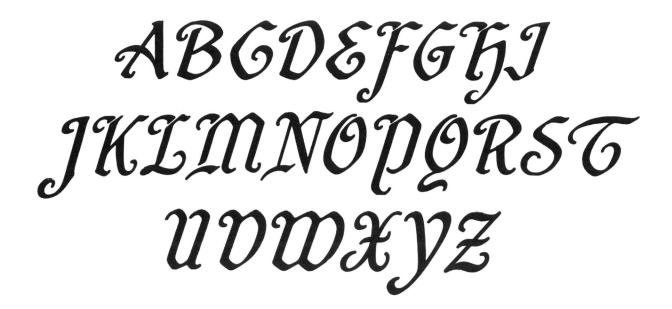

ABCDEFGHI
JKLMNOPQRST
UVWXYZ

abcdefghijklmnopq
rstuvwxyz

1234567890

&-,:;$!?

Pen Shade

ABCDEFG
HIJKLMNN
OPQRSTU
VWXYZ&X
abcdefghijk
lmnopqrs
tuvwxyz

1234567890

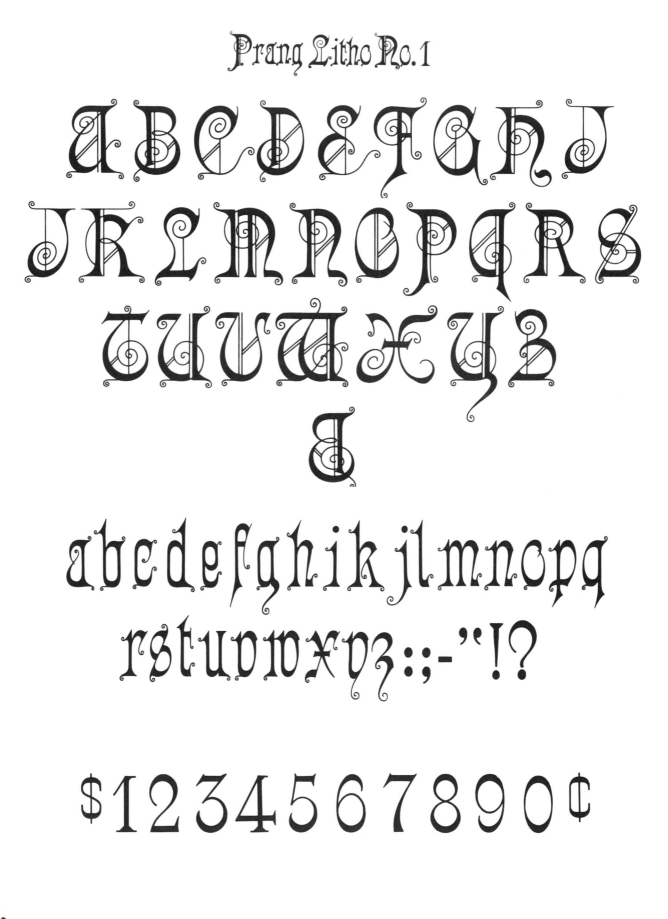

ABCDEFGHI
JKLMNOPQRS
TUVWXYZ
J

abcdefghikjlmnopq
rstuvwxyz:;-"'!?

$1234567890¢

Progressive Text

A B C D E F G H I
J K L M N O P Q R
S T U V V W X Y Z

abcdefghijklmnop
qrsftuvwxyz

1234567890
&:;,="'!?$

Psalter Text

ABCDEFGHI
JKLMNOPQR
STUVWXYZ

abcdefghijklmno
pqrstuvwxyz

$1234567890

&.,:;"'!?'"

Rhapsodie

ABCDEFGHIJKL
MNOPQRST
UVWXYZ

(&.,;-!?)

abcdefghijklmnop
qrstuvwryz

Rhapsodie Initials

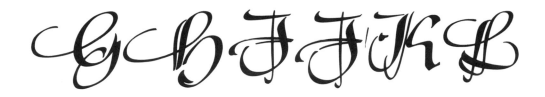

A B C D E F

G H I J K L

M N O P Q R S

T U V W X Y

Z

Rimpled Text

ABCDEFGHI
JKLMNOPQR
STUVWXYZ

abcdefghijklmno
pqrstuvwxyz

1234567890

Rumford

ABCDEFGHI
ƎKCᒪMΝOPQQR
STUᗪWXYZ

abcdefghijklmno
pqrstuvwxyz

1234567890
(&;!?$¢)

Satanick Open

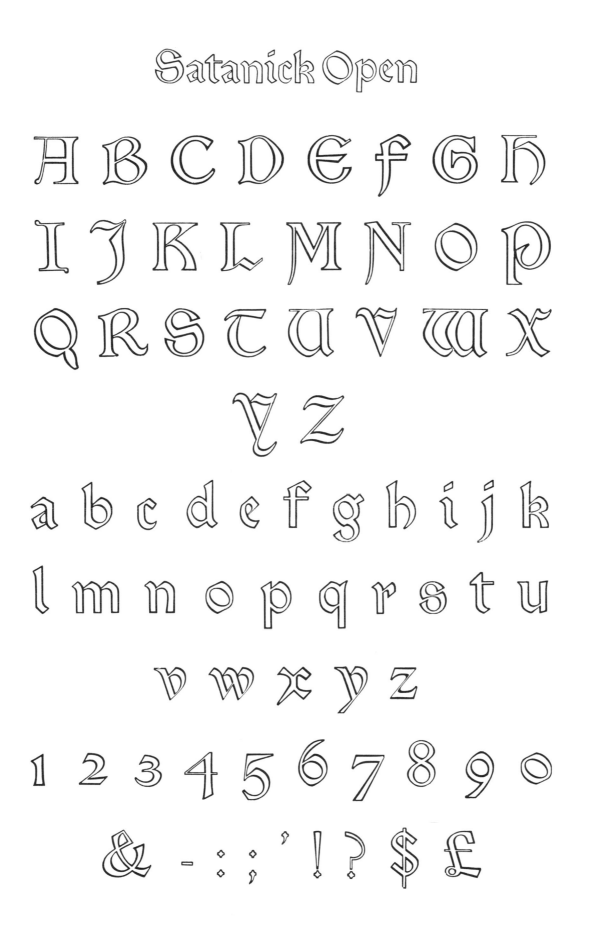

SCOTFORD UNCIAL

ABCDEFG
HIJKLM
NOPQRSTU
VWXYZ

1234567890
(&.,.:;-!?$¢)

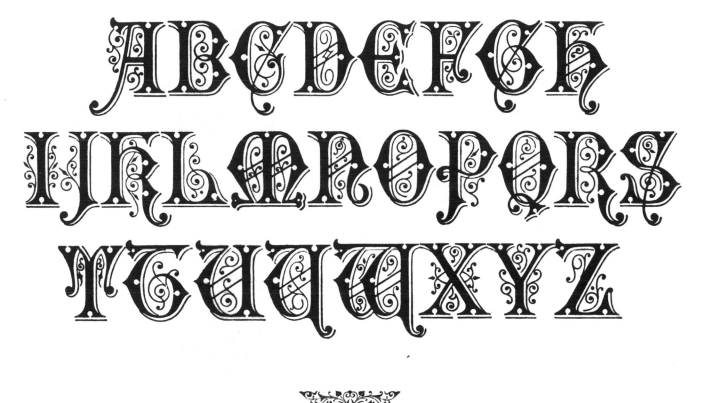

ABCDEFGH
IJKLMNOPQRS
TGUVWXYZ

ABCDEFGHIJKLMNO
PQRSTUVWXYZ

Shadow Text

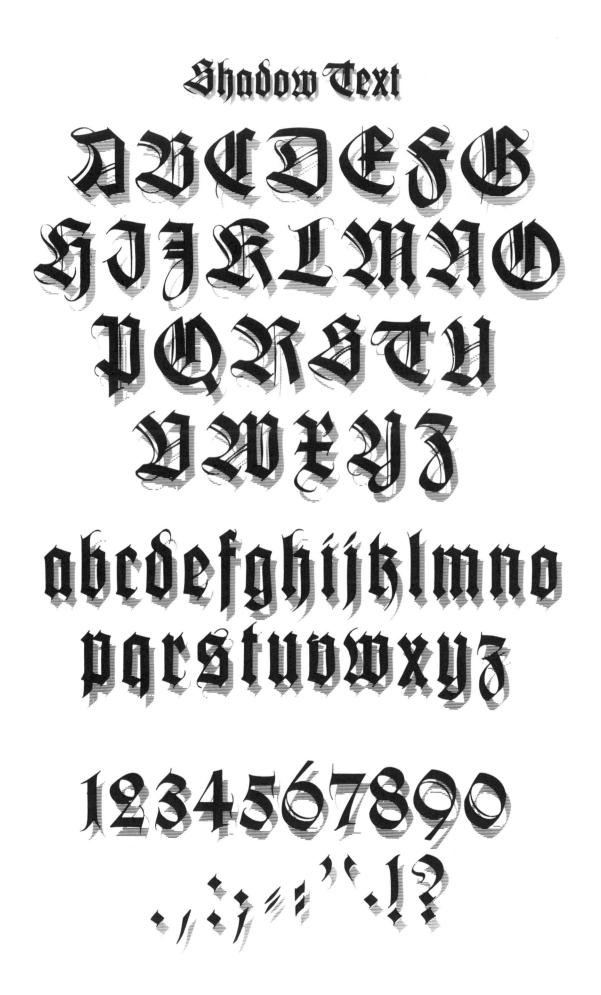

A B C D E F G
H I J K L M N O
P Q R S T U
V W X Y Z

a b c d e f g h i j k l m n o
p q r s t u v w x y z

1 2 3 4 5 6 7 8 9 0

.,;:-'"'"'.!?

Sign Text

ABCDEFGH
IJKLMNOPQR
STUVWXYZ

abcdefghijkl
mnopqrstu
vwxyz

1234567890
(&.,:;-'"!?$)

Society Text

A B C D E F G H

I J K L M N O P Q

R S T U V W

X Y Z

a b c d e f g h i j k l m n

o p q r s t u v w x y z

1 2 3 4 5 6 7 8 9 0

$, ; : . - ' ' ? ! &

SOLEMNIS

ABCDEFGH
IJKLMN
OPQRSTU
VWXYZ

1234567890
(@.,:;-""!?$¢)

Steelplate Text Shaded

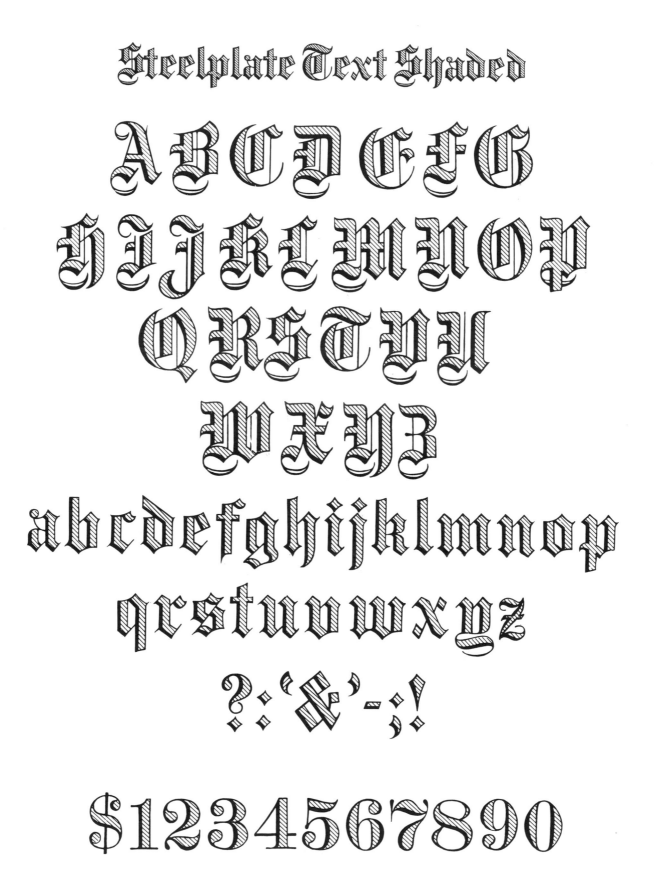

A B C D E F G
H I J K L M N O P
Q R S T V U
W X Y Z

a b c d e f g h i j k l m n o p
q r s t u v w x y z

? : ' & ' - ; !

$1234567890

STEINWAY

Territorial Shaded

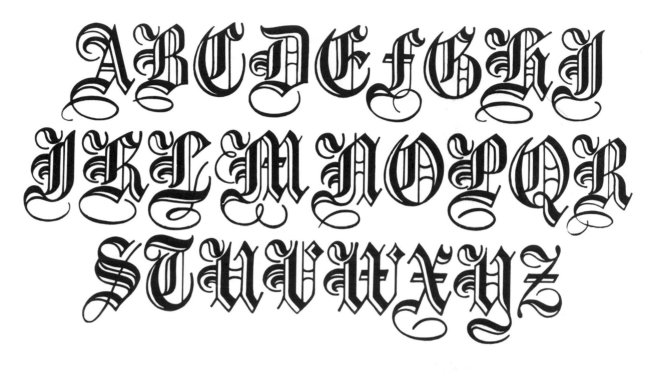

A B C D E F G H I
J K L M N O P Q R
S T U V W X Y Z

a b c d e f g h i j k l m n o p
q r s t u v w x y z

1 2 3 4 5 6 7 8 9 0
(&.,;:-''!?$¢)

Teutonic Text

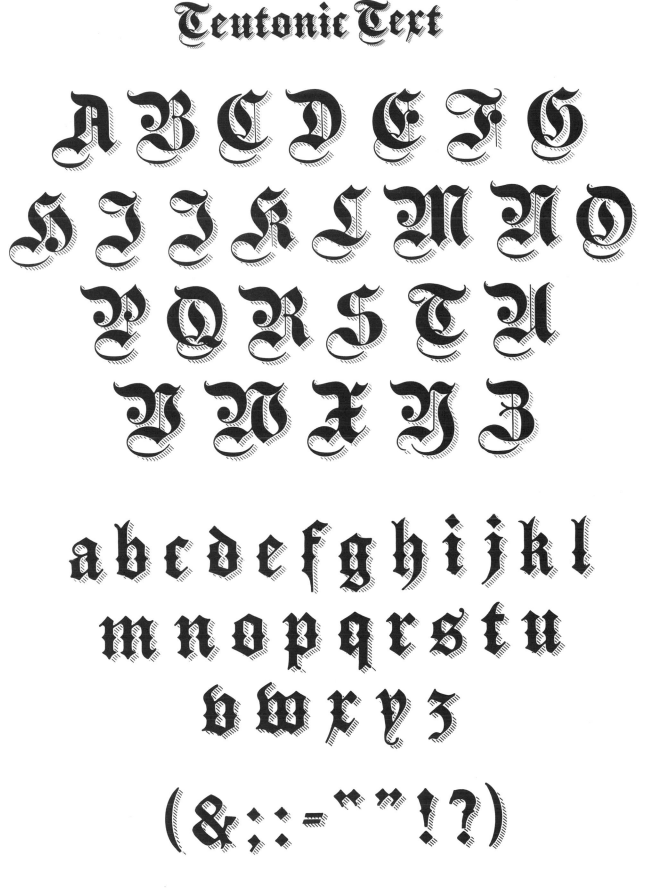

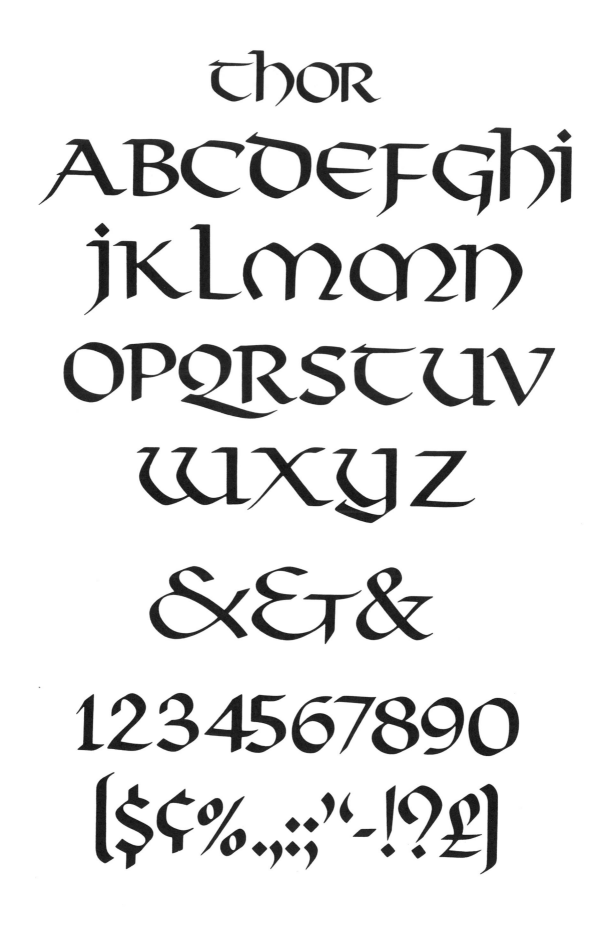

THOR

ABCDEFGHI

JKLMMN

OPQRSTUV

WXYZ

&Et&

1234567890

[$₵%.,:;"'-!?£]

Trump Deutsch

ABCDEFG
HIJKLMNO
PQRSTUV
WXYZ

abcdefghijklmn
opqrstuvwxyz

1234567890

Tudor Italic

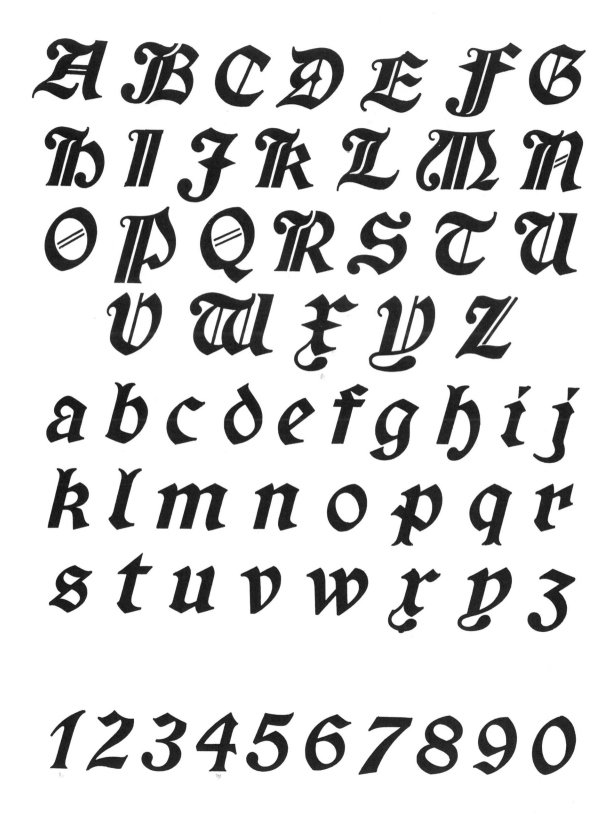

unciala

ABCDEFG
hijklmNOP
QRSTUV
WXYZ

&

1234567890

Vatican Initials

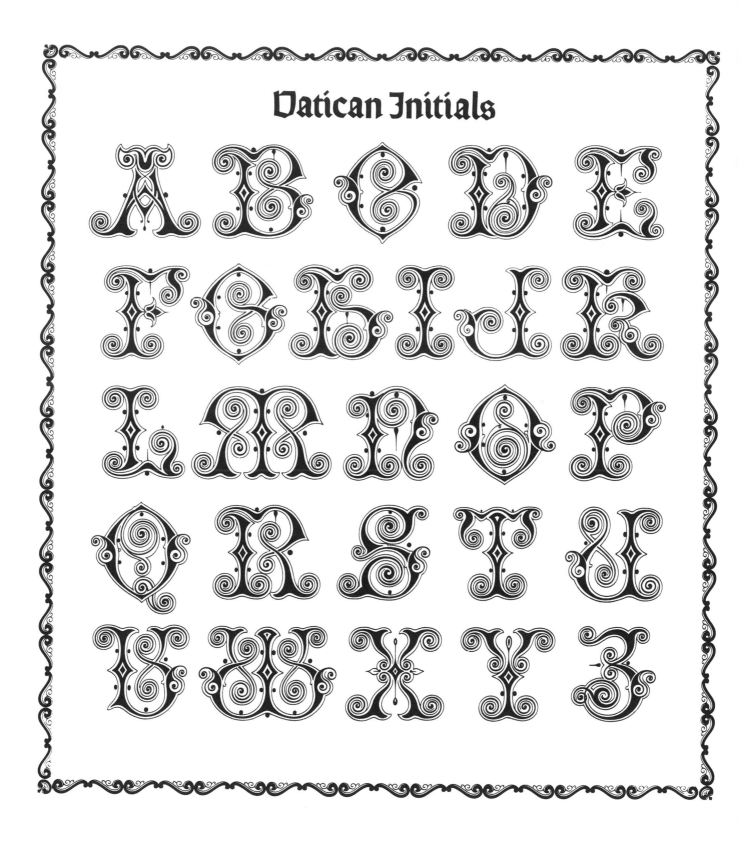

Walbaum Fraktur

ABCDEFGH
FJKLMNOPQ
RSTUVWXYZ

abcdefghijklmno
pqrsſtuvwxyz

1234567890

Washington Text

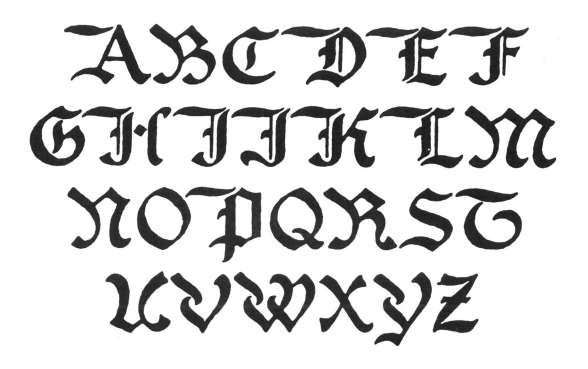

ABCDEF
GHIJKLM
NOPQRST
UVWXYZ

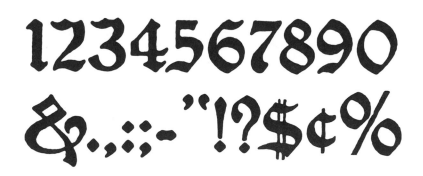

abcdefghijklmnop
qrstuvwxyz

1234567890
&.,.:;-"'!?$¢%

Wedding Text

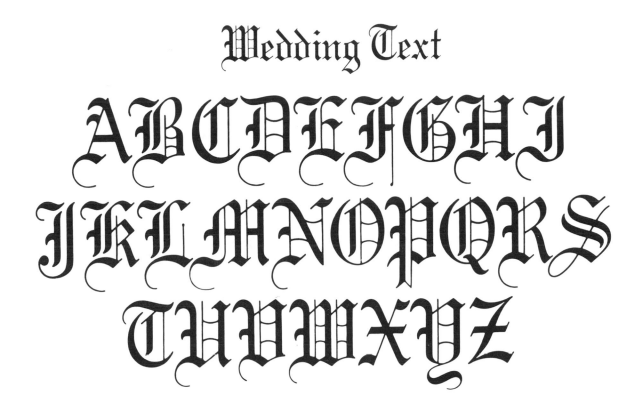

ABCDEFGHI
JKLMNOPQRS
TUVWXYZ

abcdefghijklmnop
qrstuvwxyz

1234567890

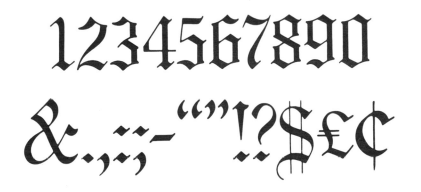

&.,:;-""!?$£¢

Weisert Initials No.1

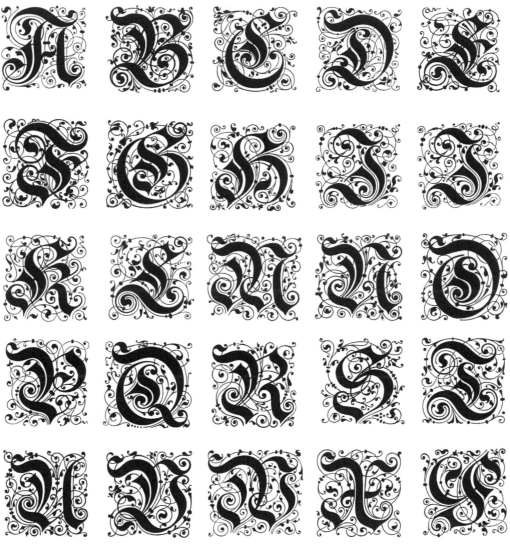

Weisert Initials No. 2

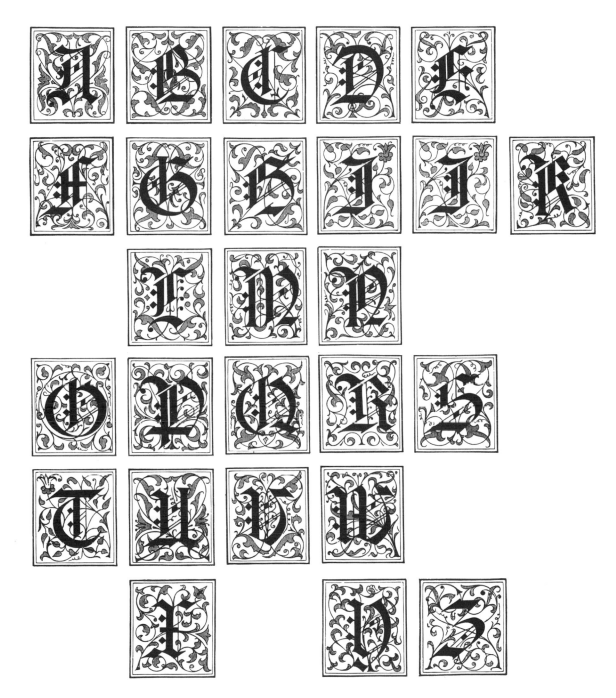

Zahner Text

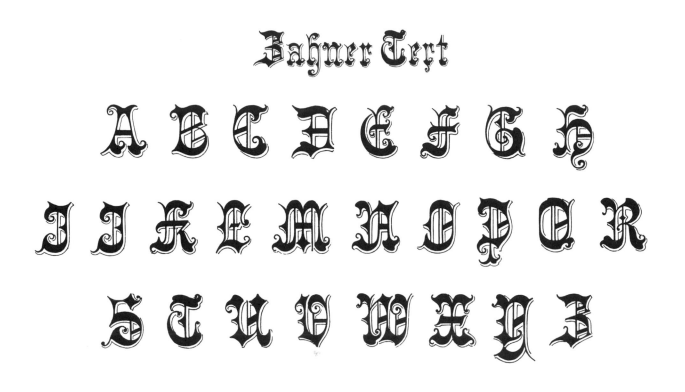

A B C D E F G H
J J K L M N O P Q R
S T U V W X Y Z

a b c d e f g h i j k l m n
o p q r s t u v w x y z

1 2 3 4 5 6 7 8 9 0

Zentenar

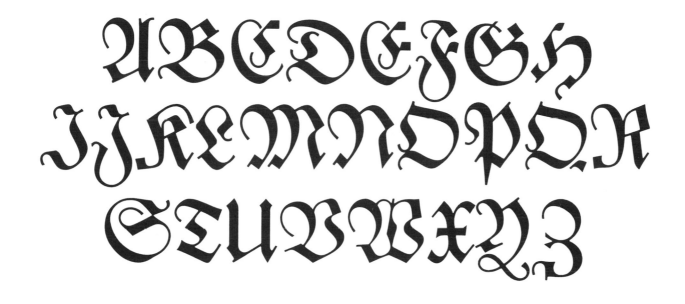

abcdefghijklmnop
qrsstuvwxyz

1234567890

Zoltan

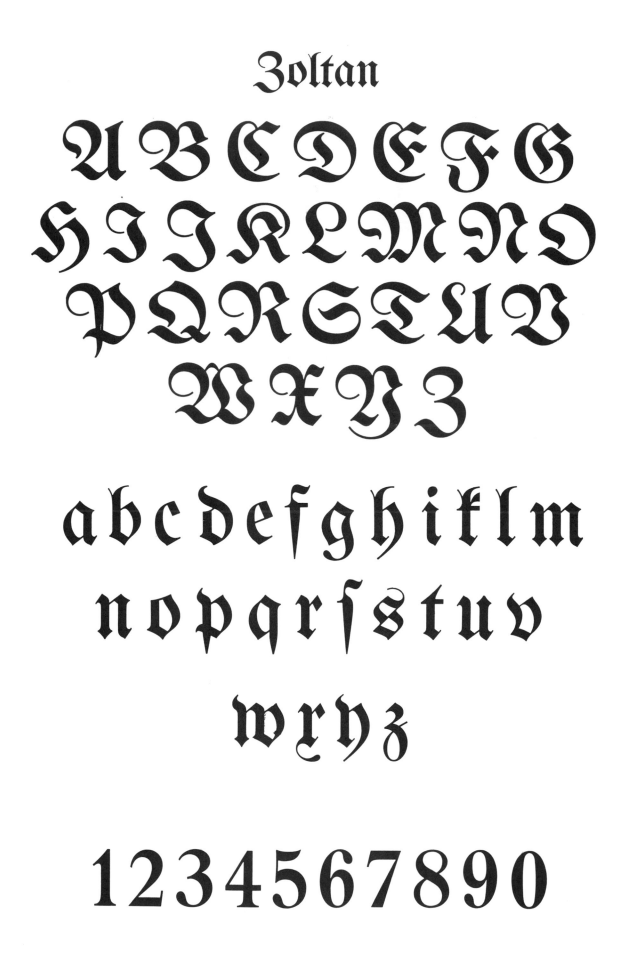

ABCDEFG
HIJKLMNO
PQRSTUV
WXYZ

abcdefghiklm
nopqrſstuv
wxyz

1234567890

GRAPHIC WORLDS OF PETER BRUEGEL THE ELDER, Peter Bruegel. 63 engravings and a woodcut made from the drawings of the 16th-century Flemish master: landscapes, seascapes, stately ships, drolleries, whimsical allegories, scenes from the Gospels, and much more. Stimulating commentaries by H. Arthur Klein on individual prints, bits of biography on etcher or engraver, and comparisons with Bruegel's original designs. 176pp. 9⅜ x 12¼. 21132-0

VIEWS OF VENICE BY CANALETTO, Antonio Canaletto (engraved by Antonio Visentini). Unparalleled visual statement from early 18th century includes 14 scenes down the Grand Canal away from and returning to the Rialto Bridge, 12 magnificent views of the inimitable *campi*, and more. Extraordinarily handsome, large-format edition. Text by J. Links. 50 illustrations. 90pp. 13¾ x 10. 22705-7

THE CRAFTSMAN'S HANDBOOK, Cennino Cennini. This fifteenth-century handbook reveals secrets and techniques of the masters in drawing, oil painting, frescoes, panel painting, gilding, casting, and more. 142pp. 6¼ x 9¼. 20054-X

THE BOOK OF KELLS, Blanche Cirker (ed.). Thirty-two full-color, full-page plates from the greatest illuminated manuscript of the Middle Ages; painstakingly reproduced from rare facsimile edition. Publisher's Note. Captions. 32pp. 9⅜ x 12¼. 24345-1

THE COMPLETE ENGRAVINGS, ETCHINGS AND DRYPOINTS OF ALBRECHT DÜRER, Albrecht Dürer. This splendid collection reproduces all 105 of Dürer's works in these media, including such well-known masterpieces as *Knight, Death and Devil, Melencolia I,* and *Adam and Eve,* plus portraits of such contemporaries as Erasmus and Frederick the Wise; popular and religious works; peasant scenes, and the portentous works: *The Four Witches, Sol Justitiae,* and *The Monstrous Sow of Landser.* 120 plates. 235pp. 8⅜ x 11¼. 22851-7

THE HUMAN FIGURE, Albrecht Dürer. This incredible collection contains drawings in which Dürer experimented with many methods: the "anthropometric system," learned from Leonardo; the "exempeda" method, known to most as the man inscribed in a circle; the human figure in motion; and much more. Some of the life studies rank among the finest ever done. 170 plates. 355pp. 8⅜ x 11¼. 21042-1

MEDIEVAL WOODCUT ILLUSTRATIONS, Carol Belanger Grafton (ed.). Selections from a 1493 history of the world features magnificent woodcuts of 91 locales, plus 143 illustrations of figures and decorative objects. Comparable to the Gutenberg Bible in terms of craftsmanship; designed by Pleydenwuff and Wolgemut. Permission-free. 194 b/w illustrations. 80pp. 8⅜ x 11. 40458-7

ENGRAVINGS OF HOGARTH, William Hogarth. Collection of 101 robust engravings reveals the life of the drawing rooms, inns, and alleyways of 18th-century England through the eyes of a great satirist. Includes all the major series: *Rake's Progress, Harlot's Progress,* Illustrations for *Hudibras, Before and After, Beer Street,* and *Gin Lane,* plus 96 more with commentary by Sean Shesgreen. xxxiii+205pp. 11 x 13¾. 22479-1

THE DANCE OF DEATH, Hans Holbein the Younger. Most celebrated of Holbein's works. Unabridged reprint of the original 1538 masterpiece and one of the great graphic works of the era. Forty-one striking woodcuts capture the motif *Memento mori*–"Remember, you will die." Includes translations of all quotes and verses. 146pp. 5⅜ x 8½. 22804-5

THE COMPLETE WOODCUTS OF ALBRECHT DÜRER, Dr. W. Kurth (ed.). Superb collection of 346 extant woodcuts: the celebrated series on the *Life of Virgin, the Apocalypse of St. John, the Great Passion, St. Jerome in His Study, Samson Fighting the Lion, The Fall of Icarus, The Rhinoceros, the Triumphal Arch, Saints and Biblical Scenes,* and many others, including much little-known material. 285pp. 8½ x 12¼. 21097-9

RELIGIOUS ART IN FRANCE OF THE THIRTEENTH CENTURY, Emile Mâle. This classic by a noted art historian focuses on French cathedrals of the 13th century as the apotheosis of the medieval style. Topics include iconography, bestiaries, illustrated calendars, the gospels, secular history, and many other aspects. 190 b/w illustrations. 442pp. 5⅜ x 8½. 41061-7

GREAT SCENES FROM THE BIBLE: 230 Magnificent 17th Century Engravings, Matthaeus Merian (the Elder). Remarkably detailed illustrations depict Adam and Eve Driven Out of the Garden of Eden, The Flood, David Slaying Goliath, Christ in the Manger, The Raising of Lazarus, The Crucifixion, and many other scenes. A wonderful pictorial dimension to age-old stories. All plates from the classic 1625 edition. 128pp. 9 x 12. 42043-4

MEDIEVAL AND RENAISSANCE TREATISES ON THE ARTS OF PAINTING: Original Texts with English Translations, Mary P. Merrifield. This rare 1849 work reprints treatises from the 12th–17th centuries (with the original-language version and its English translation on facing pages). Oil painting practices, methods of mixing pigments, and much more, with commentary on each treatise, plus excellent introduction discussing social history, artistic practices. 1,280pp. 5⅜ x 8½. 40440-4

VIEWS OF ROME THEN AND NOW, Giovanni Battista Piranesi and Herschel Levit. Piranesi's masterful representations of architecture are reprinted in large format alongside corresponding recent photos. Monuments of ancient, early Christian, Renaissance, and Baroque Rome (Colosseum, Forum, fountains, etc.) with auxiliary notes on both the etchings and photos. 82 plates. 109pp. 11 x 14¾. 23339-1

THE NOTEBOOKS OF LEONARDO DA VINCI, compiled and edited by Jean Paul Richter. These 1,566 extracts reveal the full range of Leonardo's versatile genius: his writings on painting, sculpture, architecture, anatomy, mining, inventions, and music. The first volume is devoted to various aspects of art: structure of the eye and vision, perspective, science of light and shade, color theory, and more. The second volume shows the wide range of Leonardo's secondary interests: geography, warfare, zoology, medicine, astronomy, and other topics. Dual Italian-English texts, with 186 plates and more than 500 additional drawings faithfully reproduced. Total of 913pp. 7⅞ x 10¾.
Vol. I: 22572-0
Vol. II: 22573-9

ON DIVERS ARTS, Theophilus (translated by John G. Hawthorne and C. S. Smith). Twelfth-century treatise on arts written by a practicing artist. Pigments, glass blowing, stained glass, gold and silver work, and more. Authoritative edition of a medieval classic. 34 illustrations. 216pp. 6½ x 9¼. 23784-2

THE COMPLETE ETCHINGS OF REMBRANDT: REPRODUCED IN ORIGINAL SIZE, Rembrandt van Rijn. One of the greatest figures in Western Art, Rembrandt van Rijn (1606–1669) brought etching to a state of unsurpassed perfection. This edition includes more than 300 works–portraits, landscapes, biblical scenes, allegorical and mythological pictures, and more–reproduced in full size directly from a rare collection of etchings famed for its pristine condition, rich contrasts, and brilliant printing. With detailed captions, chronology of Rembrandt's life and etchings, discussion of the technique of etching in this time, and a bibliography. 224pp. 9⅜ x 12¼. 28181-7

DRAWINGS OF REMBRANDT, Seymour Slive (ed.) Updated Lippmann, Hofstede de Groot edition, with definitive scholarly apparatus. Many drawings are preliminary sketches for great paintings and sketchings. Others are self-portraits, beggars, children at play, biblical sketches, landscapes, nudes, Oriental figures, birds, domestic animals, episodes from mythology, classical studies, and more. Also, a selection of work by pupils and followers. Total of 630pp. 9⅛ x 12¼.
Vol. I 21485-0
Vol. II 21486-9

THE MATERIALS AND TECHNIQUES OF MEDIEVAL PAINTING, Daniel V. Thompson. Sums up 20th-century knowledge: paints, binders, metals, and surface preparation. 239pp. 5⅜ x 8½. 20327-1

DRAWINGS OF ALBRECHT DÜRER, Heinrich Wölfflin (ed.). 81 plates show development from youth to full style: *Dürer's Wife Agnes, Idealistic Male and Female Figures* (Adam and Eve), *The Lamentation,* and many others. The editor not only introduces the drawings with an erudite essay, but also supplies captions for each, telling about the circumstances of the work, its relation to other works, and significant features. 173pp. 8⅛ x 11. 22352-3

*Write for **free** Fine Art and Art Instruction Catalog to*
Dover Publications, Inc., Dept. ABI, 31 East 2nd Street, Mineola, NY 11501
*Visit us online at **www.doverpublications.com***

Pictorial Archive

VICTORIAN HOUSEWARE, HARDWARE AND KITCHENWARE: A PICTORIAL ARCHIVE WITH OVER 2000 ILLUSTRATIONS, Ronald S. Barlow (ed.). This fascinating archive, reprinted from rare woodcut engravings and selected from hard-to-find antique trade catalogs, offers a realistic view of the furnishings of a typical 19th-century home, including andirons, ash sifters, housemaids' buckets, buttonhole cutters, sausage stuffers, seed strippers, spittoons, and hundreds of other items. Captions include size, weight, and cost. 376pp. 9⅜ x 12¼. 41727-1

BEARDSLEY'S LE MORTE DARTHUR: SELECTED ILLUSTRATIONS, Aubrey Beardsley. His illustrations for the great Thomas Malory classic made Aubrey Beardsley famous virtually overnight—and fired the imaginations of generations of artists with what became known as the "Beardsley look." This volume contains a rich selection of those splendid drawings, including floral and foliated openings, fauns and satyrs, initials, ornaments, and much more. Characters from Arthurian legend are portrayed in splendid full-page illustrations, bordered with evocative and fecund sinuosities of plant and flower. Artists and designers will find here a source of superb designs, graphics, and motifs for permission-free use. 62 black-and-white illustrations. 48pp. 8¼ x 11. 41795-6

TREASURY OF BIBLE ILLUSTRATIONS: OLD AND NEW TESTAMENTS, Julius Schnorr von Carolsfeld. All the best-loved, most-quoted Bible stories, painstakingly reproduced from a rare volume of German engravings. 179 imaginative illustrations depict 105 episodes from Old Testament, 74 scenes from New Testament—each on a separate page, with chapter, verse, King James Text. Outstanding source of permission-free art; remarkably accessible treatment of the Scriptures. x+182pp. 8⅜ x 11¼. 40703-9

3200 OLD-TIME CUTS AND ORNAMENTS, Blanche Cirker (ed.). Permission-free pictures from 1909 French typography catalog: plants, animals, religious motifs, music, carriages, boats, sports, furniture, clothing; plus borders, banners, wreaths, and other ornaments. More than 3,200 b/w illustrations. 112pp. 9⅜ x 12¼. 41732-8

A DIDEROT PICTORIAL ENCYCLOPEDIA OF TRADES AND INDUSTRY, Denis Diderot. First paperbound edition of 485 remarkable plates from the great 18th-century reference work. Permission-free plates depict vast array of arts and trades before the Industrial Revolution. Two-volume set. Total of 936pp. 9 x 12.
Vol. I: Agriculture and rural arts, fishing, art of war, metalworking, mining. Plates 1–208. 27428-4
Vol. II: Glass, masonry, carpentry, textiles, printing, leather, gold and jewelry, fashion, miscellaneous trades. Plates 209–485. Indexes of persons, places, and subjects. 27429-2

BIRDS, FLOWERS AND BUTTERFLIES STAINED GLASS PATTERN BOOK, Connie Clough Eaton. 68 exquisite full-page patterns; lush baskets, vases, garden bouquets, birds, and more. Perfectly rendered for stained glass; suitable for many other arts and crafts projects. 12 color illustrations on covers. 64pp. 8¼ x 11. 40717-9

TURN-OF-THE-CENTURY TILE DESIGNS IN FULL COLOR, L. François. 250 designs brimming with Art Nouveau flavor: beautiful floral and foliate motifs on wall tiles for bathrooms, multicolored stenciled friezes, and more. 48pp. 9¼ x 12¼. 41525-2

CHILDREN: A PICTORIAL ARCHIVE OF PERMISSION-FREE ILLUSTRATIONS, Carol Belanger Grafton (ed.). More than 850 versatile illustrations from rare sources depict engaging moppets playing with toys, dolls, and pets; riding bicycles; playing tennis and baseball; reading, sleeping; engaged in activities with other children; and in many other settings and situations. Appealing vignettes of bygone times for artists, designers, and craftworkers. 96pp. 9 x 12. 41797-2

504 DECORATIVE VIGNETTES IN FULL COLOR, Carol Belanger Grafton (ed.). Permission-free Victorian images of animals (some dressed in quaint period costumes, others fancifully displaying brief messages), angels, fans, cooks, clowns, musicians, revelers, and many others. 40467-6

OLD-TIME CHRISTMAS VIGNETTES IN FULL COLOR, Carol Belanger Grafton (ed.). 363 permission-free illustrations from vintage publications include Father Christmas, evergreen garlands, heavenly creatures, a splendidly decorated old-fashioned Christmas tree, and Victorian youngsters playing with Christmas toys, holding bouquets of holly, and much more. 40255-X

OLD-TIME NAUTICAL AND SEASHORE VIGNETTES IN FULL COLOR, Carol Belanger Grafton (ed.). More than 300 exquisite illustrations of sailors, ships, rowboats, lighthouses, swimmers, fish, shells, and other nautical motifs in a great variety of sizes, shapes, and styles–lovingly culled from rare 19th- and early-20th-century chromolithographs. 41524-4

BIG BOOK OF ANIMAL ILLUSTRATIONS, Maggie Kate (ed.). 688 up-to-date, detailed line illustrations–all permission-free–of monkeys and apes, horses, snakes, reptiles and amphibians, insects, butterflies, dinosaurs, and more, in accurate, natural poses. Index. 128pp. 9 x 12. 40464-1

422 ART NOUVEAU DESIGNS AND MOTIFS IN FULL COLOR, J. Klinger and H. Anker. Striking reproductions from a rare French portfolio of plants, animals, birds, insects, florals, abstracts, women, landscapes, and other subjects. Permission-free borders, repeating patterns, mortised cuts, corners, frames, and other configurations–all depicted in the sensuous, curvilinear Art Nouveau style. 32pp. 9¼ x 12¼. 40705-5

ANIMAL STUDIES: 550 ILLUSTRATIONS OF MAMMALS, BIRDS, FISH AND INSECTS, M. Méheut. Painstakingly reproduced from a rare original edition, this lavish bestiary features a spectacular array of creatures from the animal kingdom–mammals, fish, birds, reptiles and amphibians, and insects. Permission-free illustrations for graphics projects; marvelous browsing for antiquarians, art enthusiasts, and animal lovers. Captions. 112pp. 9⅜ x 12¼. 40266-5

THE ART NOUVEAU STYLE BOOK OF ALPHONSE MUCHA, Alphonse Mucha. Fine permission-free reproductions of all plates in Mucha's innovative portfolio, including designs for jewelry, wallpaper, stained glass, furniture, and tableware, plus figure studies, plant and animal motifs, and more. 18 plates in full color, 54 in 2 or more colors. Only complete one-volume edition. 80pp. 9⅜ x 12¼. 24044-4

ELEGANT FLORAL DESIGNS FOR ARTISTS AND CRAFTSPEOPLE, Marty Noble. More than 150 exquisite designs depict borders of fanciful flowers; filigreed compositions of floral sprays, wreaths, and single blossoms; delicate butterflies with wings displaying a patchwork mosaic; nosegays wrapped in lacy horns; and much more. A graceful, permission-free garden of flowers for use by illustrators, commercial artists, designers, and craftworkers. 64pp. 8⅜ x 11. 42177-5

SNOWFLAKE DESIGNS, Marty Noble and Eric Gottesman. More than 120 intricate, permission-free images of snowflakes, based on actual photographs, are ideal for use in textile and wallpaper designs, needlework and craft projects, and other creative applications. iv+44pp. 8¼ x 11. 41526-0

ART NOUVEAU FIGURATIVE DESIGNS, Ed Sibbett, Jr. Art Nouveau goddesses, nymphs, florals from posters, decorations by Alphonse Mucha. 3 gorgeous designs. 48pp. 8¼ x 11. 23444-4

ANTIQUE FURNITURE AND DECORATIVE ACCESSORIES: A PICTORIAL ARCHIVE WITH 3,500 ILLUSTRATIONS, Thomas Arthur Strange. Cathedral stalls, altar pieces, sofas, commodes, writing tables, grillwork, organs, pulpits, and other decorative accessories produced by such noted craftsmen as Inigo Jones, Christopher Wren, Sheraton, Hepplewhite, and Chippendale. Descriptive text. 376pp. 8⅜ x 11¼. 41224-5

ART NOUVEAU FLORAL PATTERNS AND STENCIL DESIGNS IN FULL COLOR, M. P. Verneuil. Permission-free art from two rare turn-of-the-century portfolios (Etude de la Plante and L'ornementation par le Pochoir) includes 159 floral and foliate motifs by M. P. Verneuil, one of the Art Nouveau movement's finest artists. The collection includes 120 images of flowers–foxglove, hollyhocks, columbine, lilies, and others–and 39 stencil designs of blossoming trees, reeds, mushrooms, oak leaves, peacocks, and more. 80pp. 9¼ x 12¼. 40126-X

Write for free Fine Art and Art Instruction Catalog to
Dover Publications, Inc., Dept. ABI, 31 East 2nd Street, Mineola, NY 11501
Visit us online at www.doverpublications.com

Art Instruction

CALLIGRAPHY, Arthur Baker. Generous sampling of work by foremost modern calligrapher: single letters, words, sentences, ventures into abstract and Oriental calligraphy, and more. Over 100 original alphabets. Foreword by Tommy Thompson. 160pp. 11⅜ x 8¼. 40950-3

PRACTICAL GUIDE TO ETCHING AND OTHER INTAGLIO PRINTMAKING TECHNIQUES, Manly Banister. Detailed illustrated instruction in etching, engraving, aquatint, drypoint, and mezzotint—from preparing plate to mounting print. No better guide for beginners. 128pp. 8⅜ x 11¼. 25165-9

ILLUSTRATING NATURE: HOW TO PAINT AND DRAW PLANTS AND ANIMALS, Dorothea Barlowe and Sy Barlowe. Practical suggestions for the realistic depiction of natural subjects. Includes step-by-step demonstrations using a variety of media. More than 400 illustrations; great for pros or amateurs. 128pp. 8¼ x 10⅞. 29921-X

PAINTING GARDENS, Norman Battershill. Expert guide for painting flower beds, landscapes, vegetable gardens, trees, and much more. Magnificently illustrated. 128pp. 8¼ x 11⅜. 28401-8

ACRYLIC WATERCOLOR PAINTING, Wendon Blake. Excellent step-by-step coverage of painting surfaces, colors, and mediums as well as basic techniques: washes, wet-in-wet, drybrush, scumbling, opaque, and more. 75 paintings demonstrate extraordinary variety of techniques. 105 black-and-white illustrations. 32 color plates. 152pp. 8⅜ x 11¼. 29912-0

FIGURE DRAWING STEP BY STEP, Wendon Blake. Profusely illustrated volume provides thorough exposition of figure drawing. More than 175 illustrations accompany demonstrations, showing how to establish major forms, refine lines, block in broad shadow areas, and finish the work. 80pp. 8⅜ x 11. 40200-2

OIL PORTRAITS STEP BY STEP, Wendon Blake. A wealth of detailed, practical advice and valuable insights on basic techniques; planning, composing, and lighting the portrait; working with other media, and more. More than 120 illustrations (including 57 in full color) act as step-by-step guides to painting a variety of male and female subjects. 64pp. 8⅜ x 11¼. 40279-7

TEXTURE AND DETAIL IN WATERCOLOR, Richard Bolton. Complete course covers paints, papers, brushes; also techniques: scratching-out, wax resist, split-brush, spattering, sponging, and more. Full chapters on trees, surface textures, flowers, much else. Full color illustrations. 128pp. 8⅜ x 11. 29509-5

PEN AND PENCIL DRAWING TECHNIQUES, Harry Borgman. Manual by acclaimed artist contains the best information available on pencil and ink techniques, including 28 step-by-step demonstrations—many of them in full color. 256pp., including 48 in color. 474 black-and-white illustrations and 73 color illustrations. 8⅜ x 11. 41801-4

CONSTRUCTIVE ANATOMY, George B. Bridgman. More than 500 illustrations; thorough instructional text. 170pp. 6⅛ x 9¼. 21104-5

DRAWING THE DRAPED FIGURE, George B. Bridgman. One of the foremost drawing teachers shows how to render seven different kinds of folds: pipe, zigzag, spiral, half-lock, diaper pattern, drop, and inert. 200 b/w illustrations. 64pp. 6½ x 9¼. 41802-2

ANIMAL SKETCHING, Alexander Calder. Undisputed master of the simple expressive line. 141 full body sketches and enlarged details of animals in characteristic poses and movements. 62pp. 5⅜ x 8½. 20129-5

CHINESE PAINTING TECHNIQUES, Alison Stilwell Cameron. The first guide to unify the philosophical and imitative methods of instruction in the art of Chinese painting explains the tools of the art and basic strokes and demonstrates their use to represent trees, flowers, boats, and other subjects. Hundreds of illustrations. 232pp. 9¼ x 9. 40708-X

LEARN TO DRAW COMICS, George Leonard Carlson. User-friendly guide from 1930s offers wealth of practical advice, with abundant illustrations and nontechnical prose. Creating expressions, attaining proportion, applying perspective, depicting anatomy, simple shading, achieving consistency, characterization, drawing children and animals, lettering, and more. 64pp. 8⅜ x 11. 42311-5

CARLSON'S GUIDE TO LANDSCAPE PAINTING, John F. Carlson. Authoritative, comprehensive guide covers every aspect of landscape painting; 34 reproductions of paintings by author. 58 explanatory diagrams. 144pp. 8⅜ x 11. 22927-0

THE PAINTER'S CRAFT, W. G. Constable. Clear, jargon-free introduction to craft of painting, concentrating on wax, pastel, watercolor, fresco, tempera, oil. Index. 38 illustrations. 148pp. 5⅜ x 8½. 23836-9

YOU CAN DRAW CARTOONS, Lou Darvas. Generously illustrated, user-friendly guide by popular illustrator presents abundance of valuable pointers for both beginners and experienced cartoonists: pen and brush handling; coloring and patterns; perspective; depicting people, animals, expressions, and clothing; how to indicate motion; use of comic gimmicks and props; caricatures; political and sports cartooning; and more. viii+152pp. 8⅜ x 11. 42604-1

PATTERN DESIGN, Lewis F. Day. Master techniques for using pattern in wide range of design applications including architectural, textiles, print, and more. Absolute wealth of technical information. 272 illustrations. x+306pp. 5⅜ x 8½. 40709-8

COLOR YOUR OWN DEGAS PAINTINGS, Edgar Degas (adapted by Marty Noble). Excellent adaptations of 30 works by renowned French Impressionist—among them A Woman with Chrysanthemums, Dancer Resting, and The Procession (At the Race Course). 32pp. 8¼ x 11. 42376-X

METHODS AND MATERIALS OF PAINTING OF THE GREAT SCHOOLS AND MASTERS, Sir Charles Lock Eastlake. Foremost expert offers detailed discussions of methods from Greek and Roman times to the 18th century—including such masters as Leonardo, Raphael, Perugino, Correggio, Andrea del Sarto, and many others. 1,024pp. 5⅜ x 8½. 41726-3

THE ART AND TECHNIQUE OF PEN DRAWING, G. Montague Ellwood. Excellent reference describes line technique; drawing the figure, face, and hands; humorous illustration; pen drawing for advertisers; landscape and architectural illustration; and more. Drawings by Dürer, Holbein, Doré, Rackham, Beardsley, Klinger, and other masters. 161 figures. x+212pp. 5⅜ x 8½. 42605-X

ART STUDENTS' ANATOMY, Edmond J. Farris. Long a favorite in art schools. Basic elements, common positions and actions. Full text, 158 illustrations. 159pp. 5⅜ x 8½. 20744-7

ABSTRACT DESIGN AND HOW TO CREATE IT, Amor Fenn. Profusely illustrated guide covers geometric basis of design, implements and their use, borders, textile patterns, nature study and treatment. More than 380 illustrations include historical examples from many cultures and periods. 224pp. 5⅜ x 8½. 27673-2

PAINTING MATERIALS: A SHORT ENCYCLOPEDIA, R. J. Gettens and G. L. Stout. Thorough, exhaustive coverage of materials, media, and tools of painting through the ages based on historical studies. 34 illustrations. 333pp. 5⅜ x 8½. 21597-0

LIFE DRAWING IN CHARCOAL, Douglas R. Graves. Innovative method of drawing by tonal masses. Step-by-step demonstrations and more than 200 illustrations cover foreshortening, drawing the face, and other aspects. 176pp. 8¼ x 11. 28268-6

CREATING WELDED SCULPTURE, Nathan Cabot Hale. Profusely illustrated guide, newly revised, offers detailed coverage of basic tools and techniques of welded sculpture. Abstract shapes, modeling solid figures, arc welding, large-scale welding, and more. 196 illustrations. 208pp. 8⅜ x 11¼. 28135-3

FIGURE DRAWING, Richard G. Hatton. Stresses actual drawing, rather than anatomy per se. Adult males, females, child. 100 pages on face alone. Basic book. 377 illustrations. 350pp. 5⅜ x 8½. 21377-3

HAWTHORNE ON PAINTING, Charles W. Hawthorne. Collected from notes taken by students at famous Cape Cod School; hundreds of direct, personal, and pertinent observations on technique, painting ideas, self criticism, etc. A mine of ideas, aperçus, and suggestions for artists. 91pp. 5⅜ x 8½. 20653-X

*Write for free Fine Art and Art Instruction Catalog to
Dover Publications, Inc., Dept. ABI, 31 East 2nd Street, Mineola, NY 11501
Visit us online at www.doverpublications.com*